# Puppy Love

# Puppy Love

Hugo Ross

BLACK & WHITE PUBLISHING

First published 2017
by Black & White Publishing Ltd
29 Ocean Drive, Edinburgh EH6 6JL

1 3 5 7 9 10 8 6 4 2    17 18 19 20

ISBN: 978 1 78530 084 4

The publisher has made every reasonable effort to contact copyright holders of
images in this book. Any errors are inadvertent and anyone who for any reason has
not been contacted is invited to write to the publisher so that a full
acknowledgment can be made in subsequent editions of this work.

A CIP catalogue record for this book is available from the British Library.

Typeset by 3btype.com

Images used on p83, p94, p128, p129 and p139 © iStock
All other images © Shutterstock

# Introduction

As the well-known saying goes, dog is man's best friend. Since time immemorial we have had a furry companion by our side, on our lap, or under our feet. The love we have for our dogs is often stronger than that which we have for many people! But still there is no sight more heartwarming than two dogs cuddled up together, no bond stronger than between canine chums, no bed comfier than a puppy pile.

Whether they are sharing their bowls, out on a walk together, playing with their favourite toy, or are snuggled up together in their comfiest sofa spot, one thing is for sure: there is no love quite like puppy love. Whether young or old, big or small, this fantastic collection of photographs is filled with beautiful images of canine kindred spirits.

Perfect for dog lovers, or simply lovers, *Puppy Love* is a collection of dogs at their most adorable and is sure to melt any heart.

I solemnly swear that . . . you're the cutest Dalmatian I've ever seen!

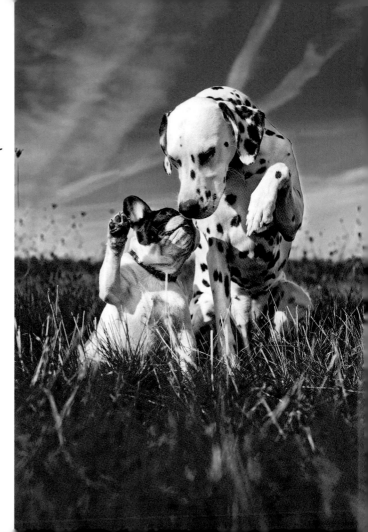

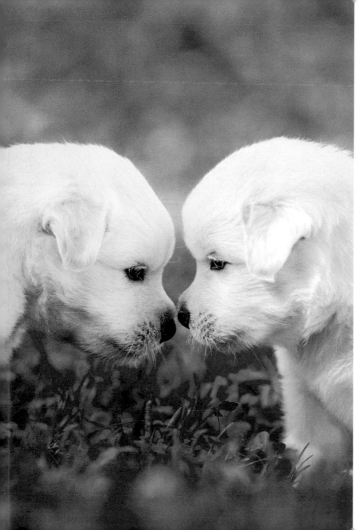

Did anyone
ever tell
you that
you have
beautiful
eyes?

I SAID: YOUR HAIR
LOOKS REALLY
NICE TODAY!

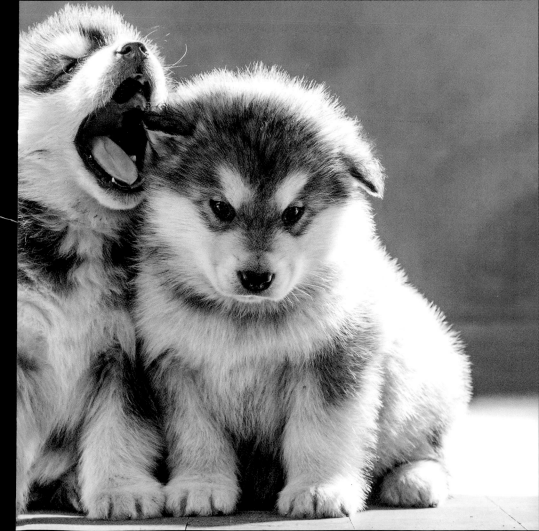

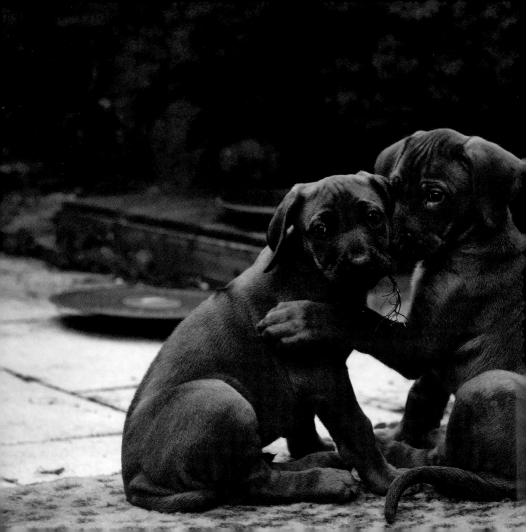

Come on pal,
it's not worth it.
Don't listen to the
neighbour's cat,
everyone knows
he's a jerk.

Oh my God,
Chuck's finally
kissing me!

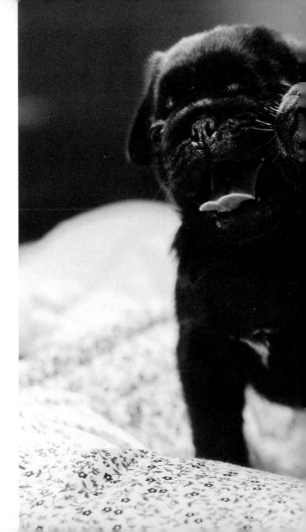

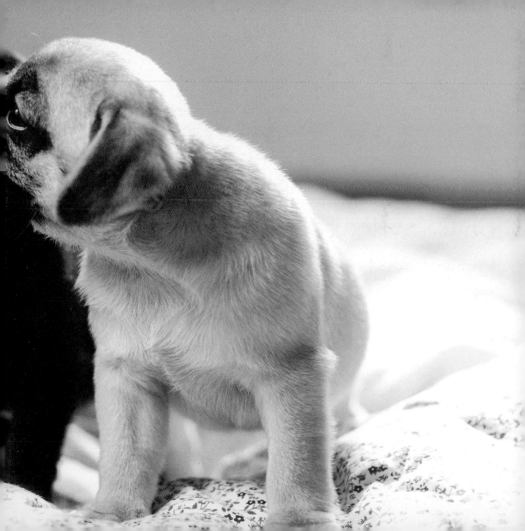

It's like I always say: when life gets you down, just chew on your own leg.

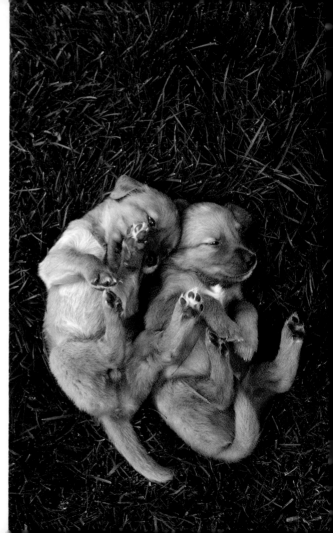

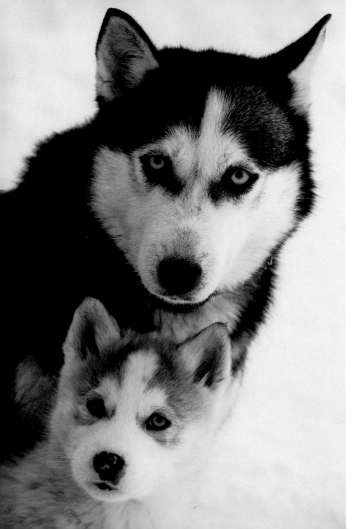

So you had the ball in your hand the whole time? Why would you do that to us?

How my heart
soars when
you whisper
sweet nothings
in my ear.

Enough football! Time to give me some attention!

Did so much today.
So much running.
No way we could
manage a bath . . .

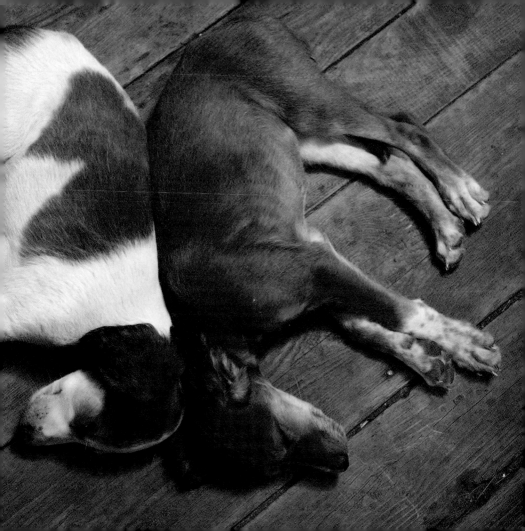

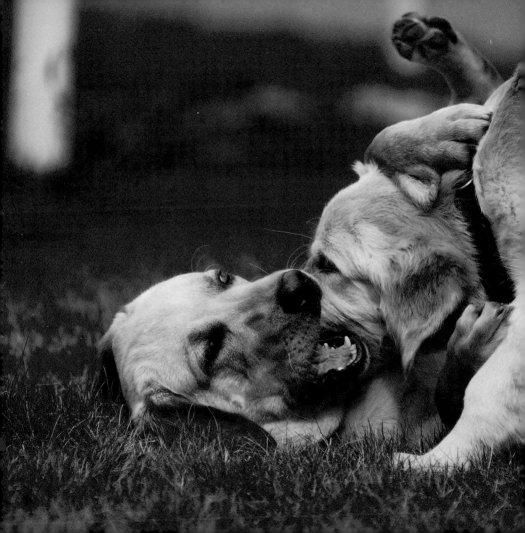

Woah, calm down,
Fergus! I didn't
know it was your
favourite slipper!
I swear!

17

I don't think
you realise
what you just
rolled in, pal.

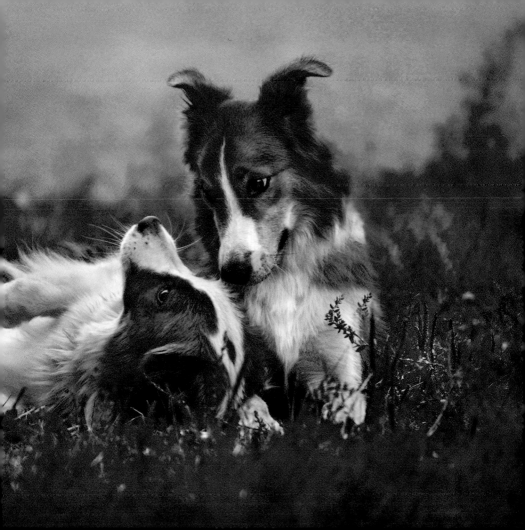

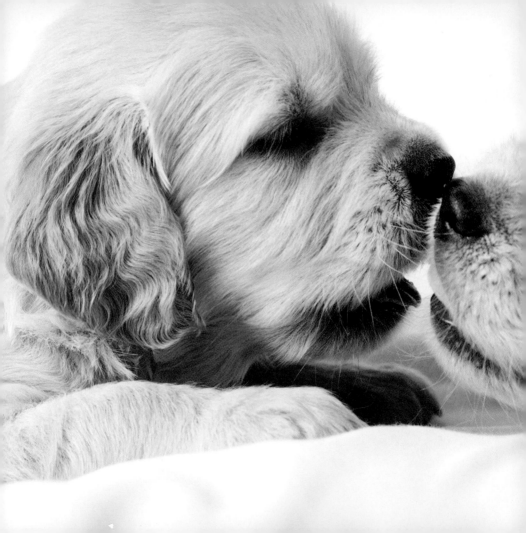

Get away!
I specifically
said no tongues!

Pssst, here's the secret - you just pretend like you don't know where the ball has gone, they like that.

Let's just get this family portrait over with. My face hurts and I'm sick of you all.

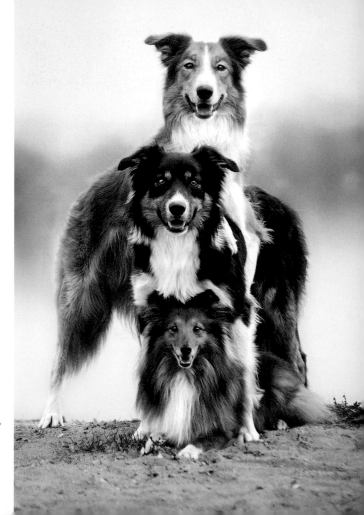

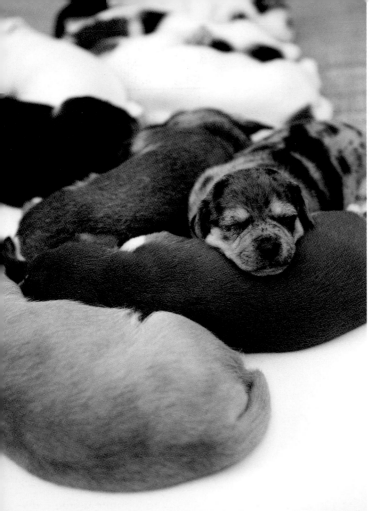

It really is exhausting being so cute.

Oh Benji, I didn't know you felt this way!

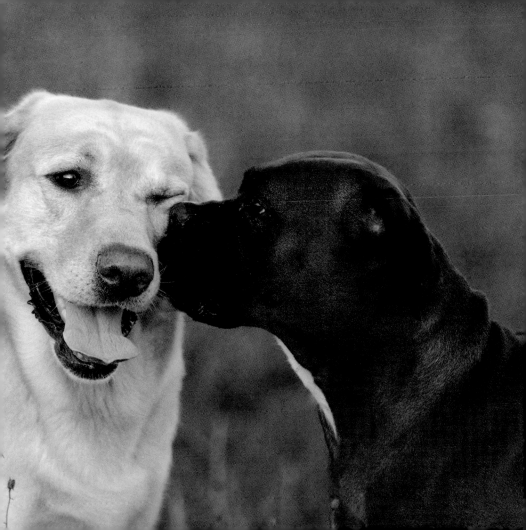

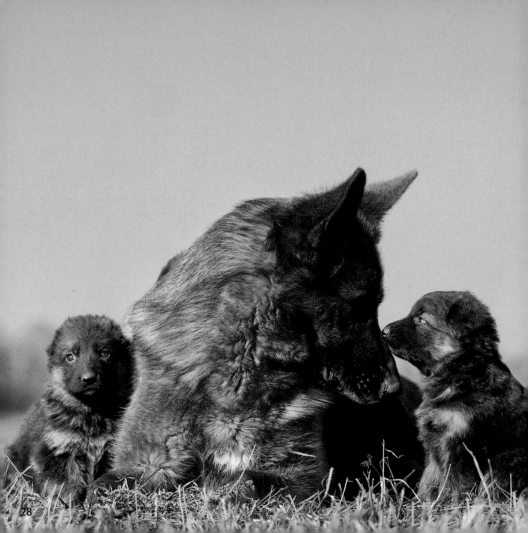

Look me in the eyes. Now tell me honestly: did you eat your own poop?

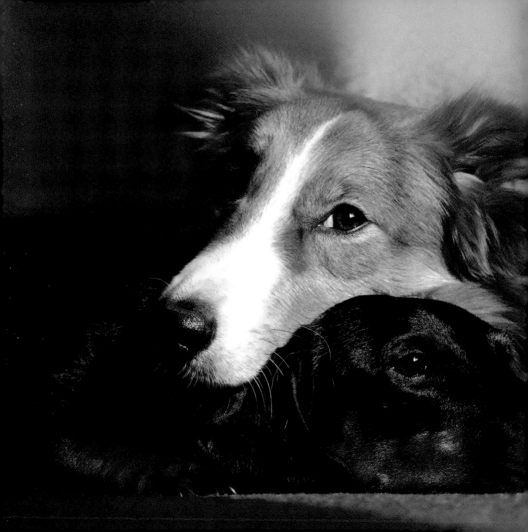

We've perfected looking cute and pathetic at the same time! They'll surely give us treats soon, right?

Fred . . . I know you're comfy but I can't breathe.

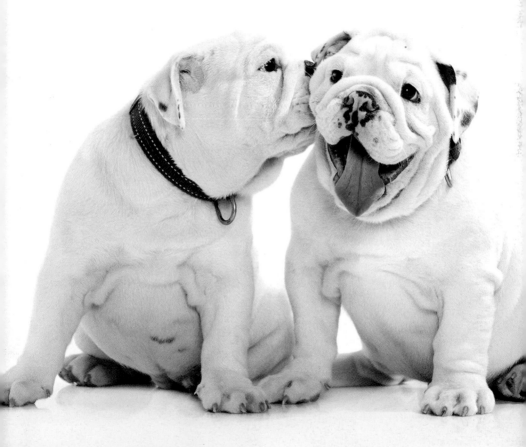

NOW can we snuggle?

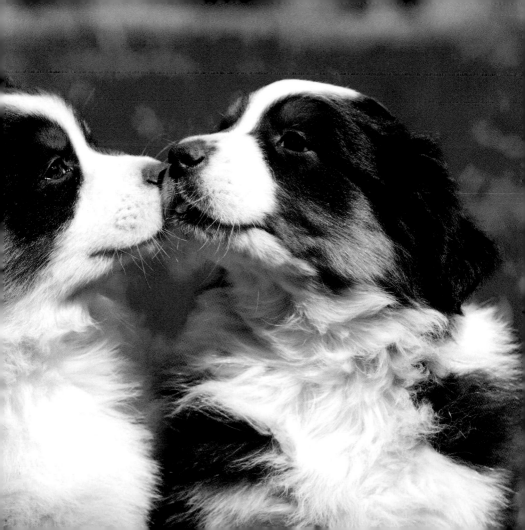

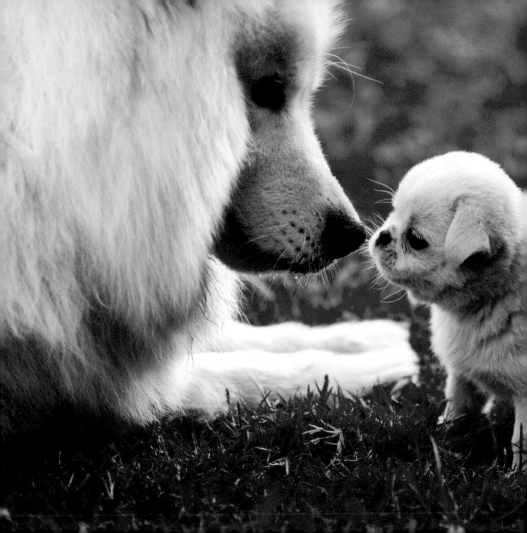

Cute cuddly thing, at your service.

Blowing raspberries
on my tummy
was fun two
hours ago . . .

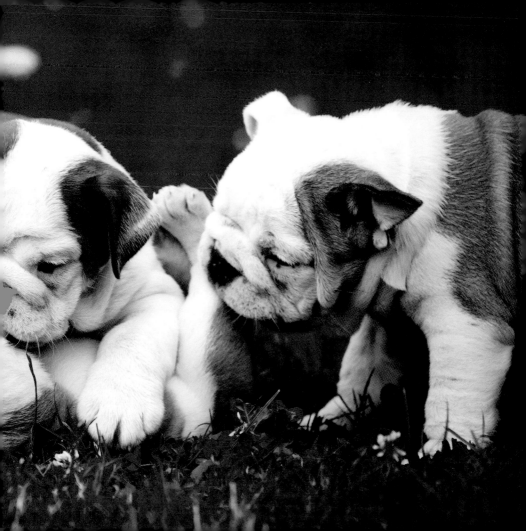

All we need now
is a theme tune!

We brought you this ball and also love!

I told you we
shouldn't have
turned left
back there!

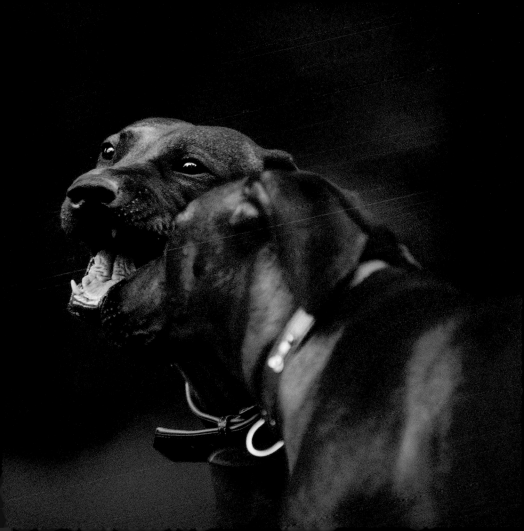

Before you see what's downstairs, you should know how much we love you.

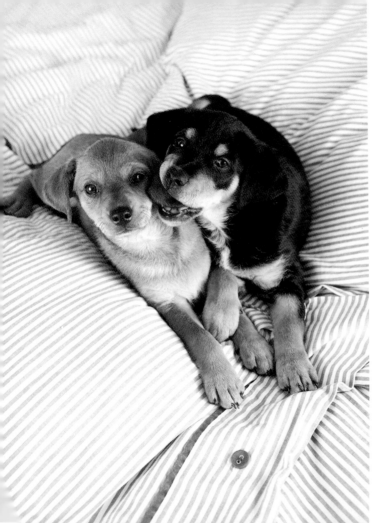

Shall I
nibble
your ear
in this
one –
that's
romantic
right?

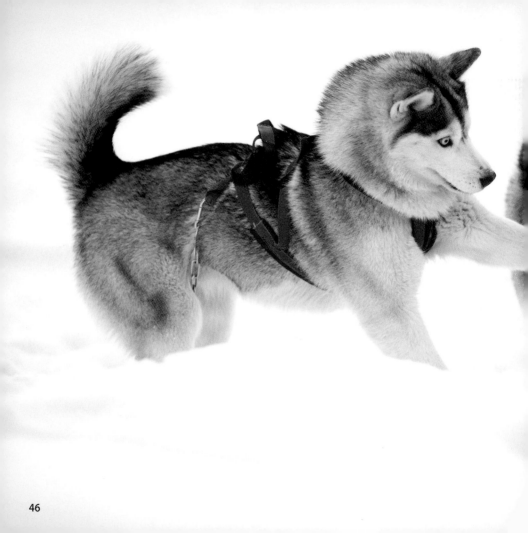

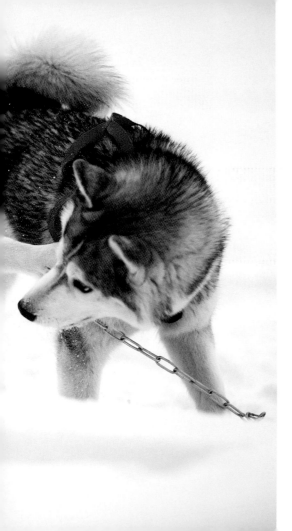

BOOP!
I booped you.

Fifi, I'm pretty confident that we are totally gonna nail that three-legged race next week.

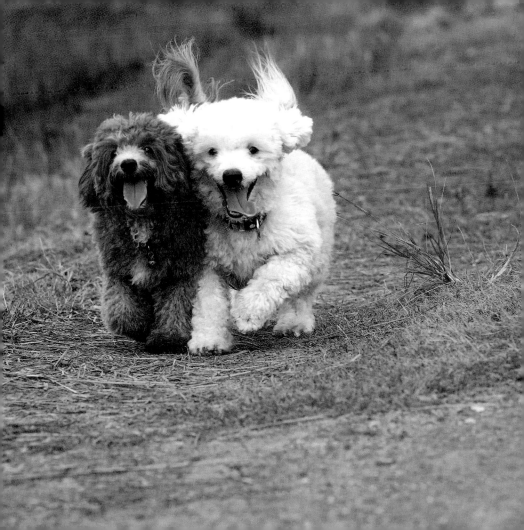

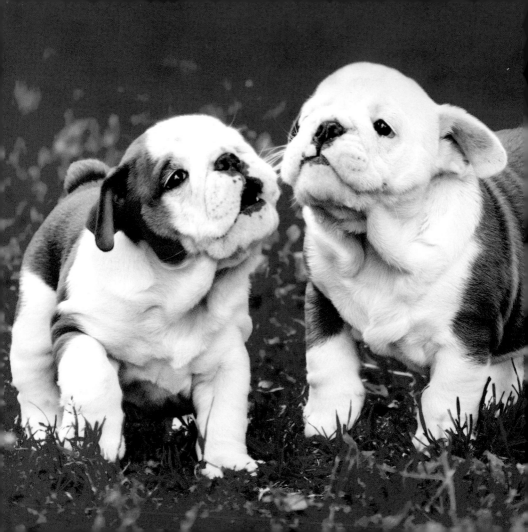

We're supposed to be youngsters in love! Why are we so wrinkly?!

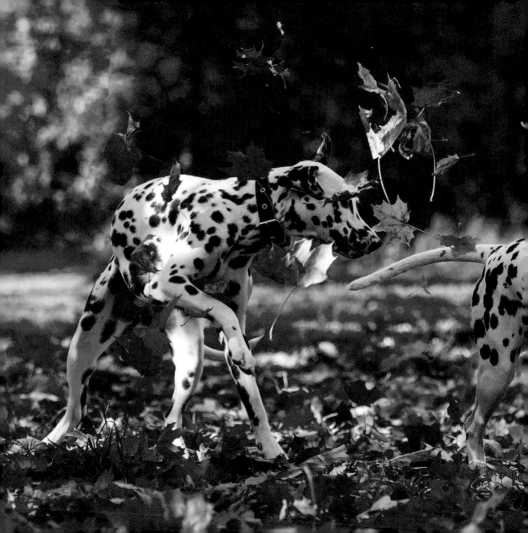

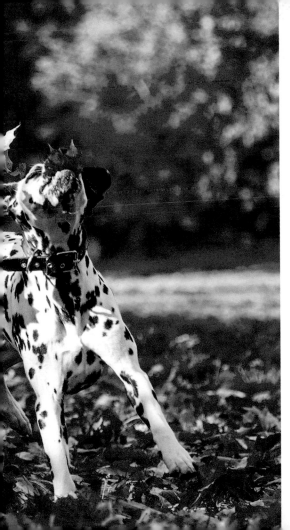

This will be great practice for when we make it through to the final round of the Crystal Maze!

We are SO
worth it.

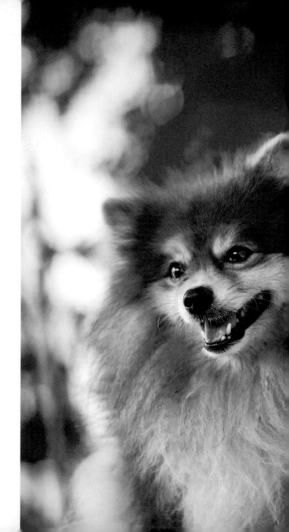

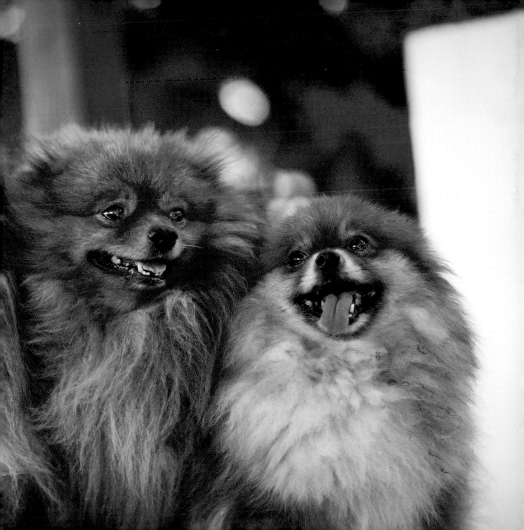

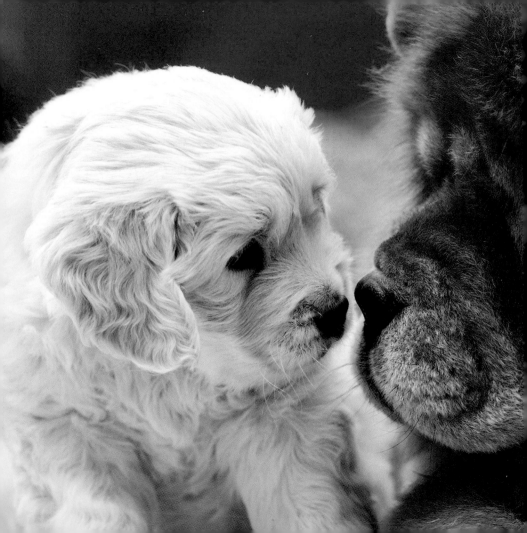

Wow. You must
drink a lot of
protein shakes,
huh?

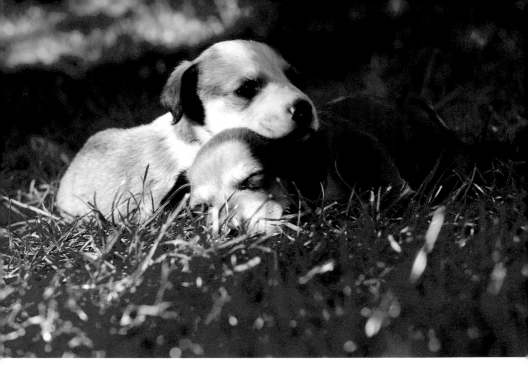

You want to do something? . . .
Nah, me neither.

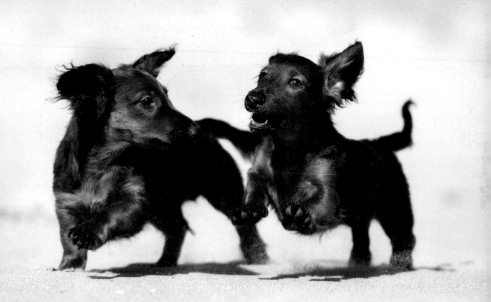

It's hard to look at you lovingly
when I'm running on hot sand!

I think this could be the start of a beautiful friendship . . .

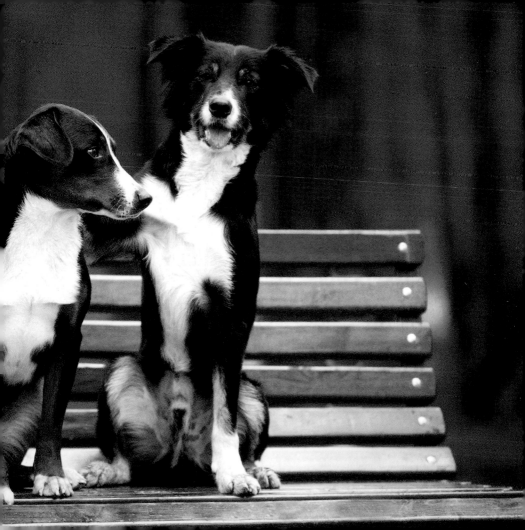

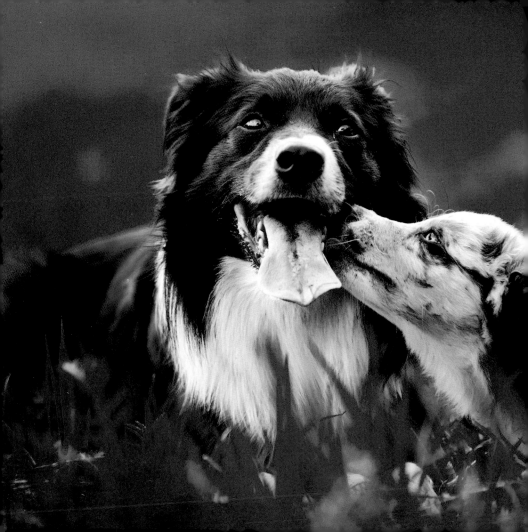

I like your face.

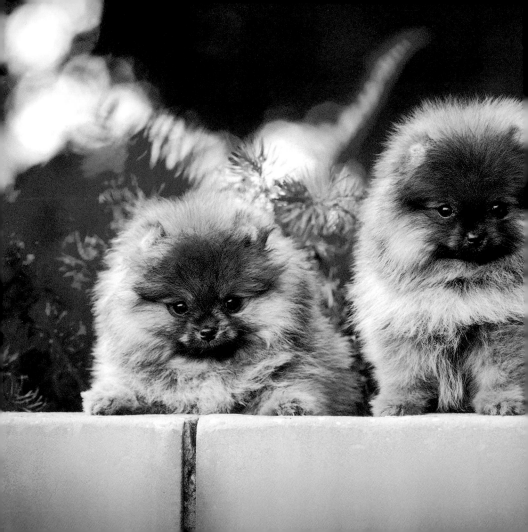

Are you just going to stand there staring at us, or are you going to help us down from this flowerbed?

That feeling when you're the only one in the family who doesn't snore . . .

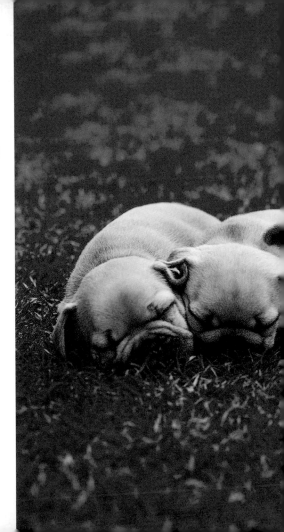

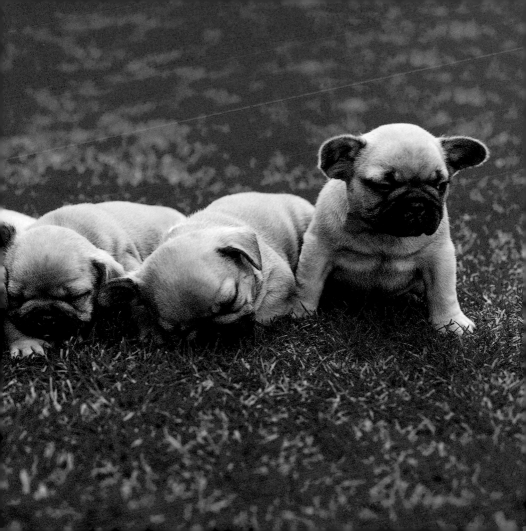

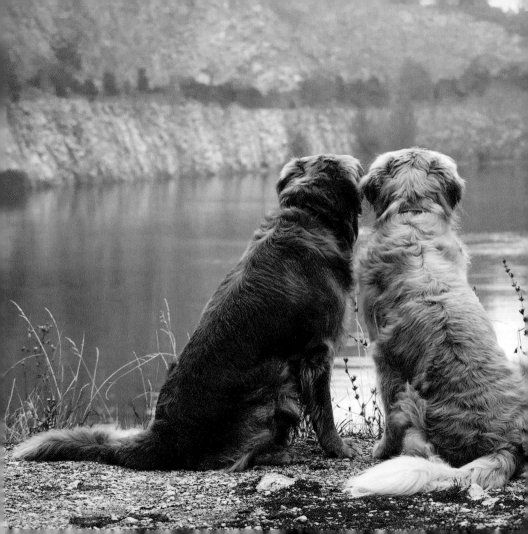

This is gonna look
so sweet on my
Instagram.

This is what
you meant by
'walkies', right?

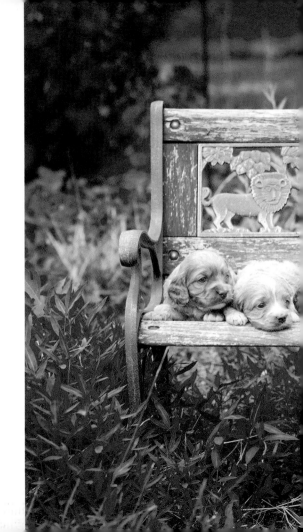

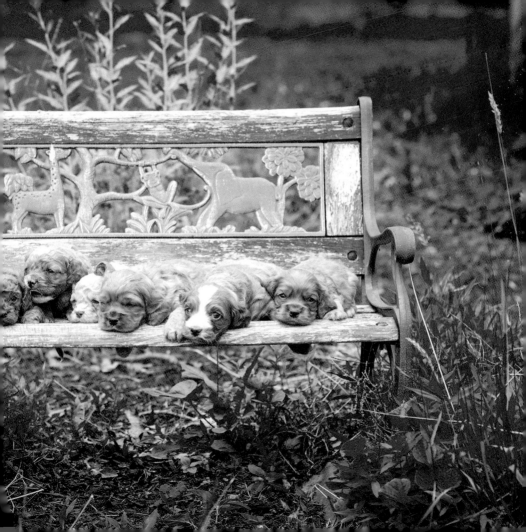

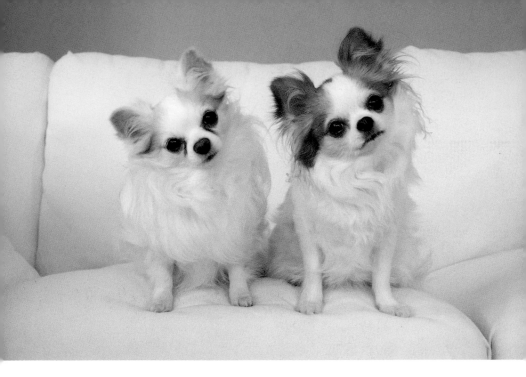

We are so in sync.

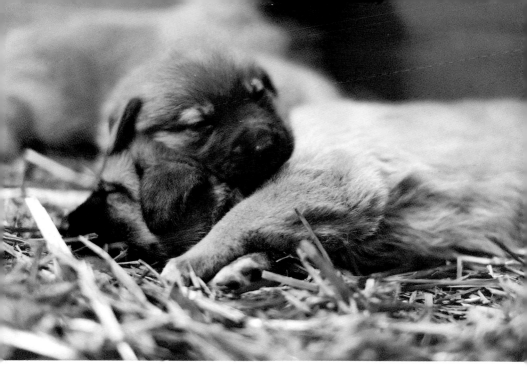

I am so glad you are both my
sweetheart and my pillow.

Since you're new to the romance game, I'll take the lead.

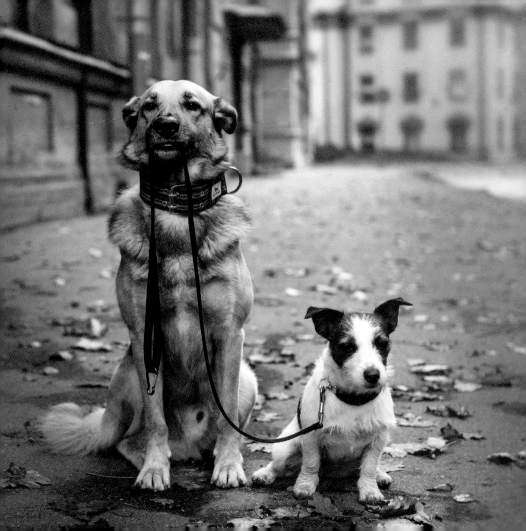

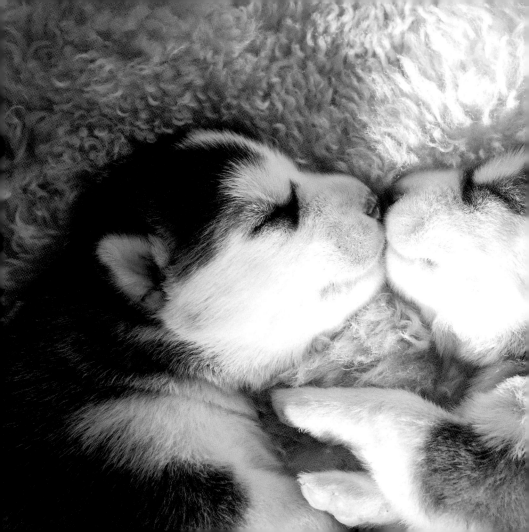

I just love the smell of your morning breath!

Trying to smile for
the camera but . . .
SO. SO. BRIGHT.

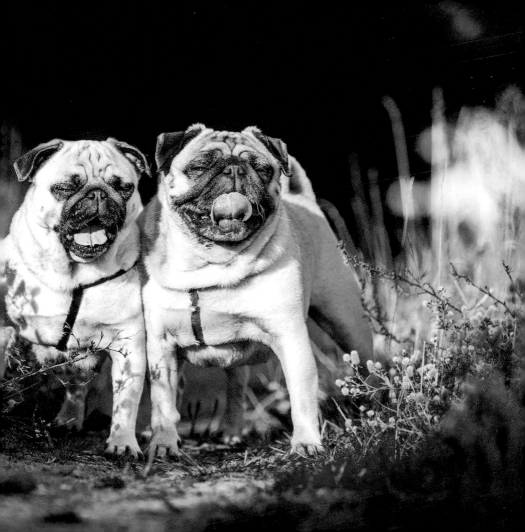

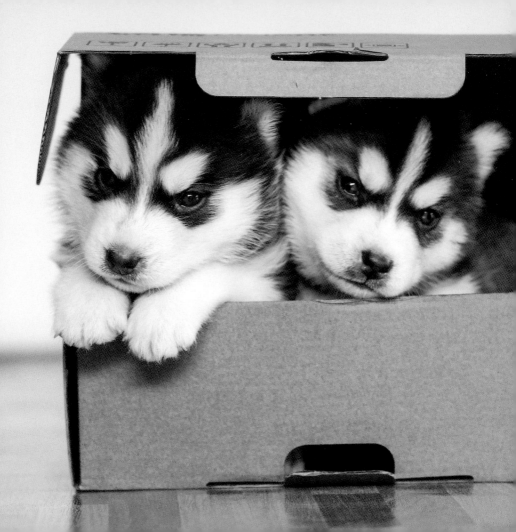

This box is perfect for cuddling in!

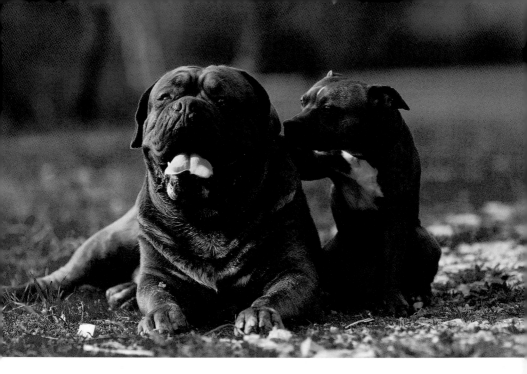

Chin up, mate. Plenty more
fish and all that.

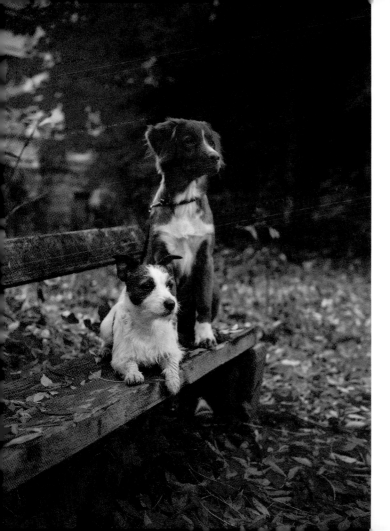

Can you
smell
bacon?

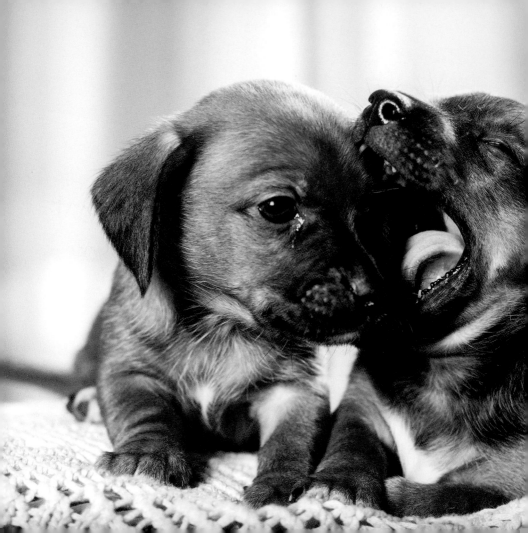

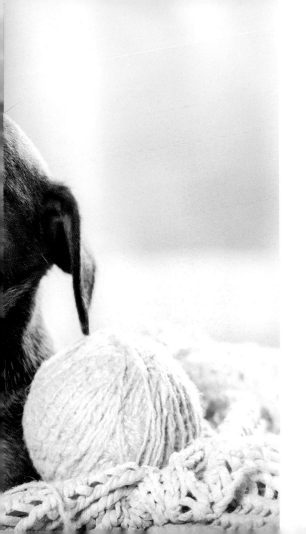

Oh, is my knitting chat keeping you awake?

85

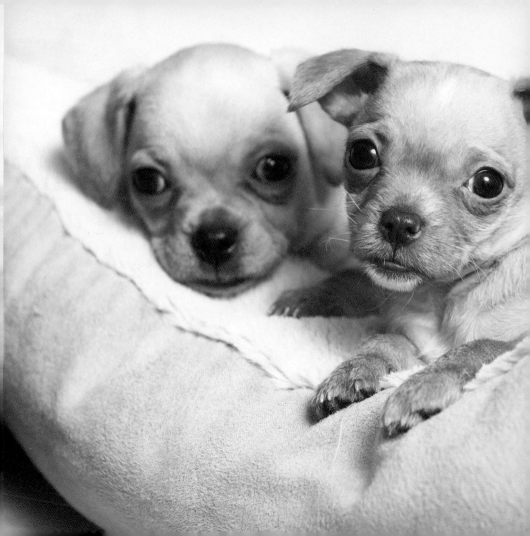

It's not just
a phase,
we're in love!

Timing that all-important first kiss can be tricky . . .

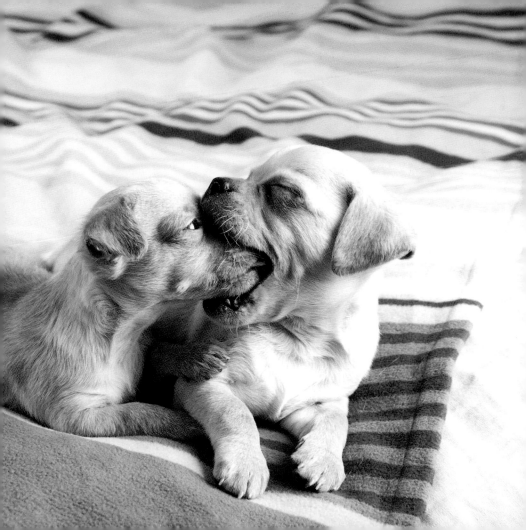

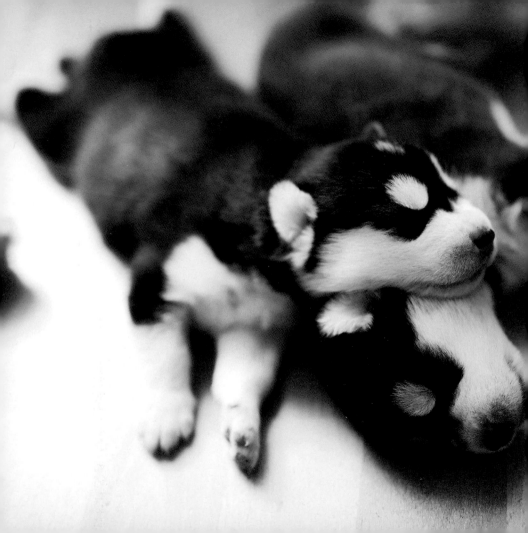

We're just
getting our
beauty sleep,
come back
in five.

Come back!
I wanna play!

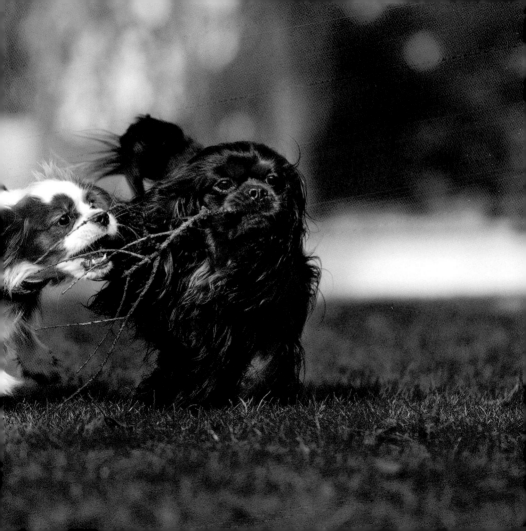

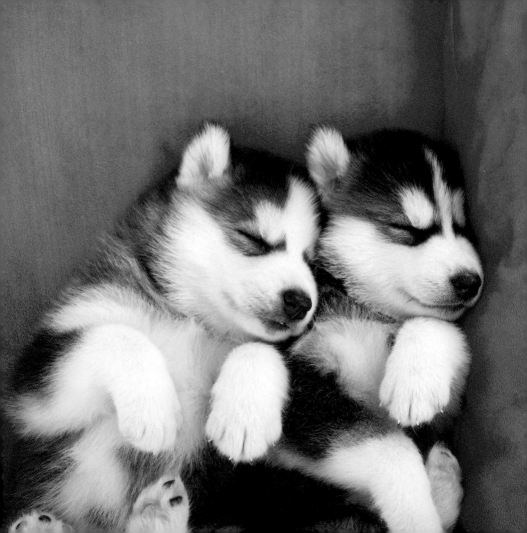

Just keep your
eyes closed; we
look too cute
to be blamed
for the slippers.

You have a blob of
something delicious
and meaty on your
nose. Let me just
get that for you . . .

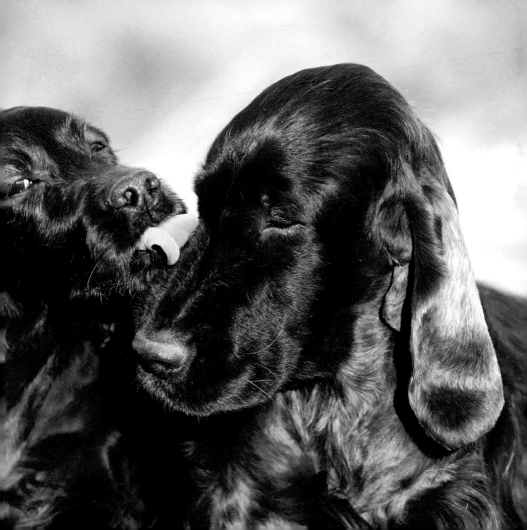

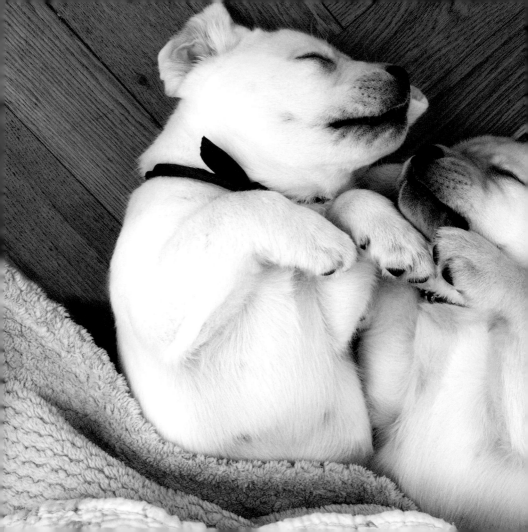

Not having thumbs makes tying your own bows exhausting!

I never want
to wake up.

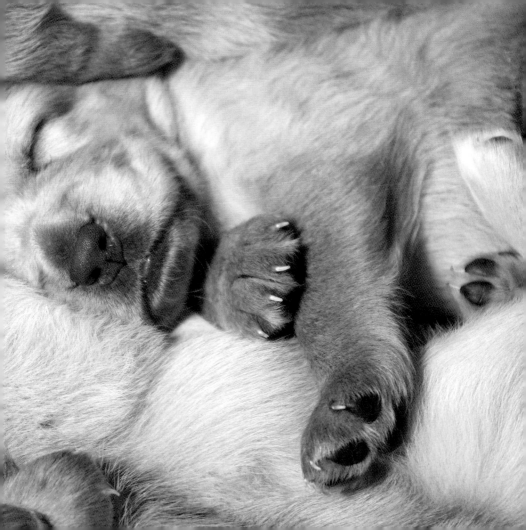

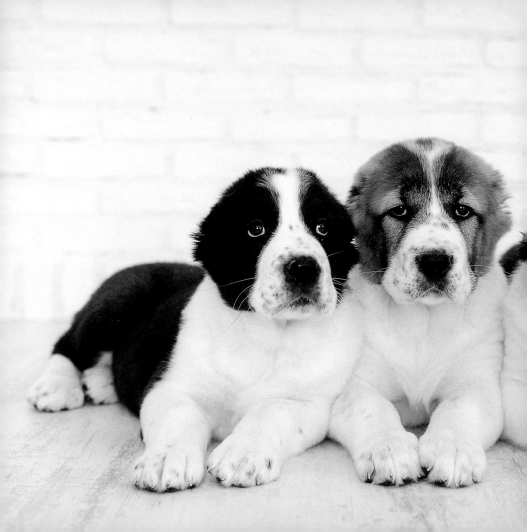

We were going for 'love', but it's turned out more 'heartbreak and teenage angst'.

What do you mean love never lasts?

Not sure how we ended up in this book, we're normally in the dictionary next to the definition of 'cuteness'.

You should be
kissed. And often.
And by someone
who knows how.

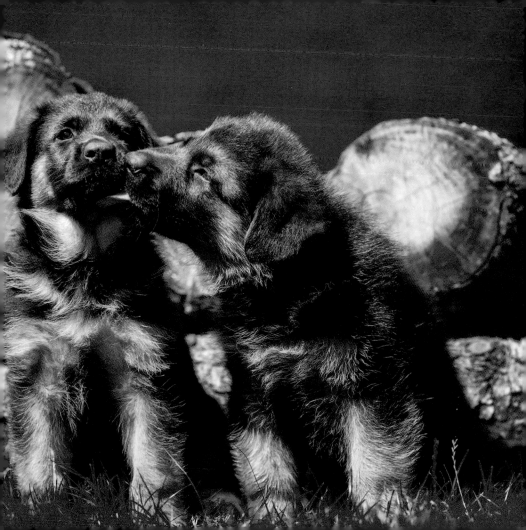

Right, let's make it that I'm Lady, you're the Tramp and this frisbee is a piece of spaghetti . . .

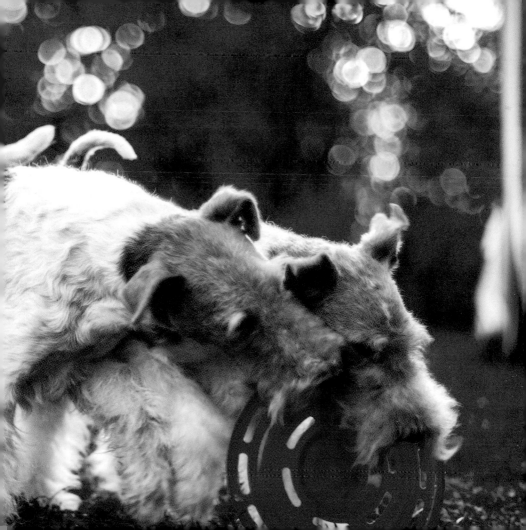

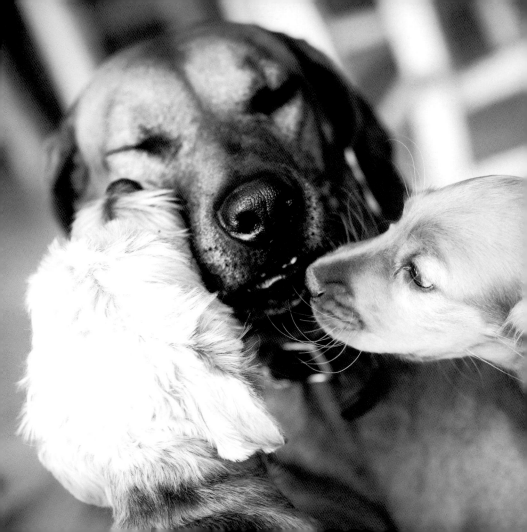

We just want
you to know,
at all times,
that we really,
really love you.

Would you mind giving us some privacy please?

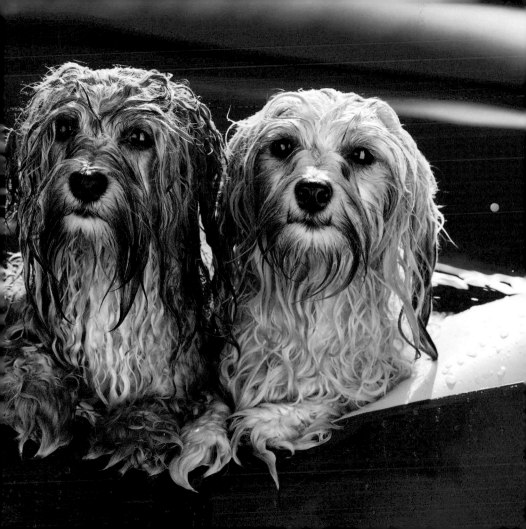

What? You had some Mr Whippy on your nose!

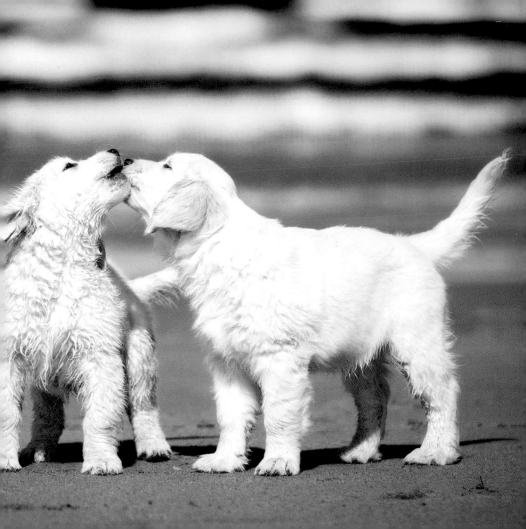

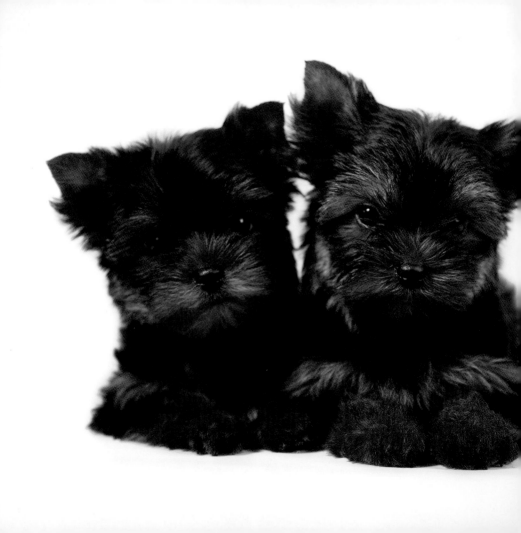

We know what you're thinking, and the answer is no. We could not possibly get any cuter.

Darling, when are they bringing the piña colada I ordered?

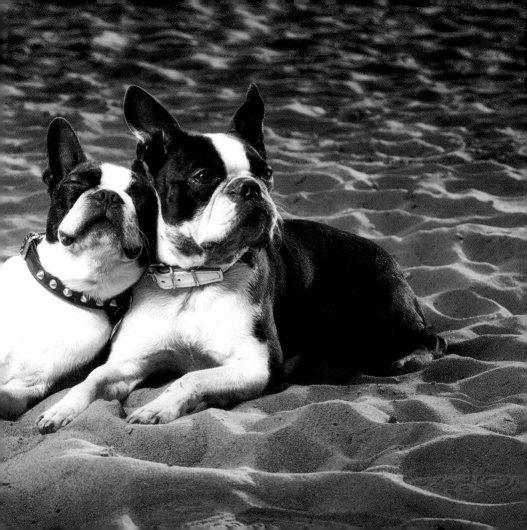

Fetch the toilet roll! I've got an idea for an advert that will make us loads of money!

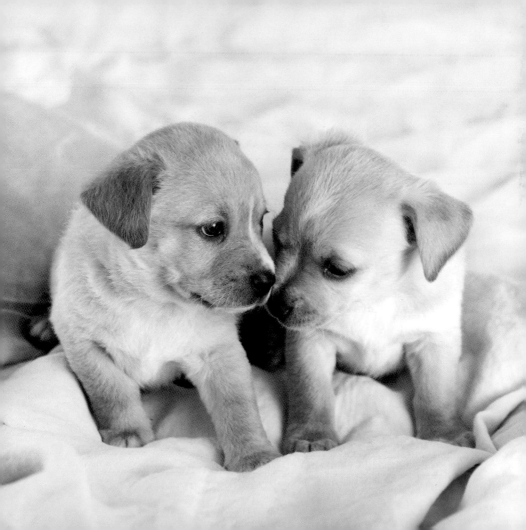

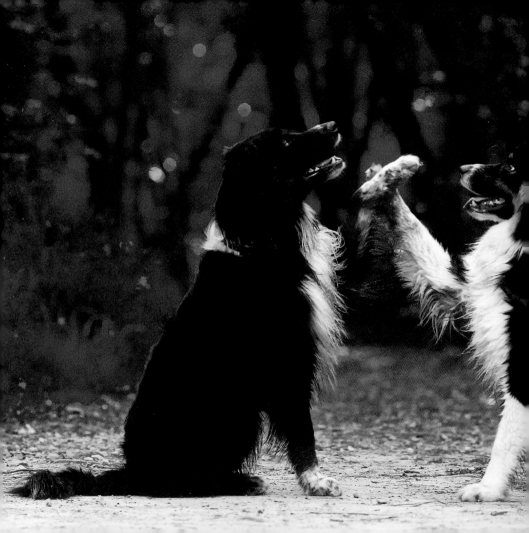

Nobody puts
Puppy in the
corner . . .

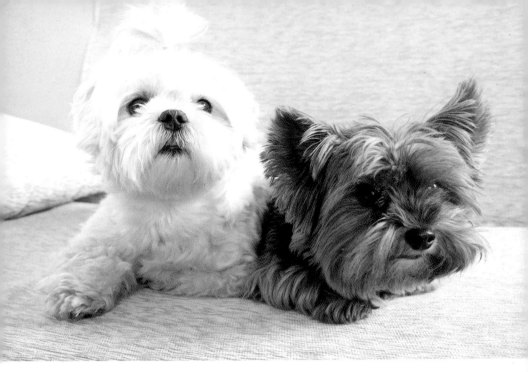

We're here to audition for the
roles of Baby and Ginger Spice!

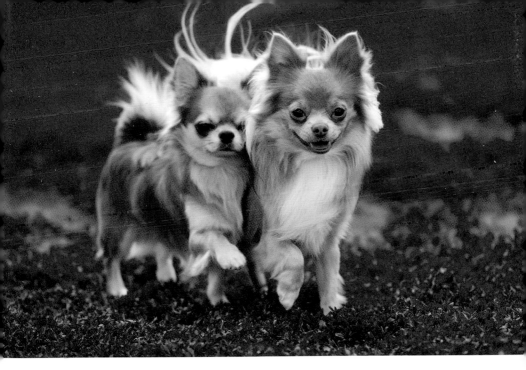

Back off man. She's pretty
but she's mine.

You might well get your looks from your father's side of the family, but remember that his mother had cankles.

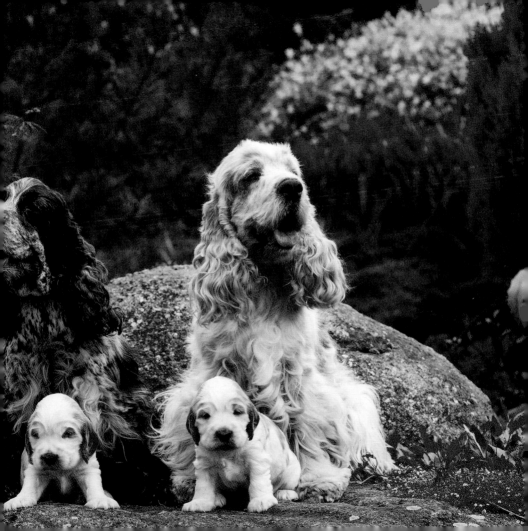

Kiss me,
you fool!

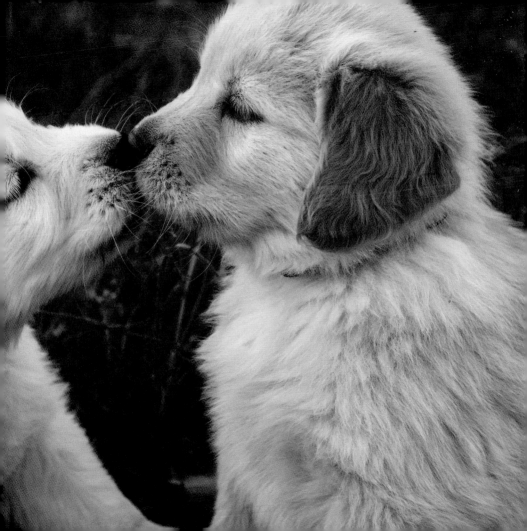

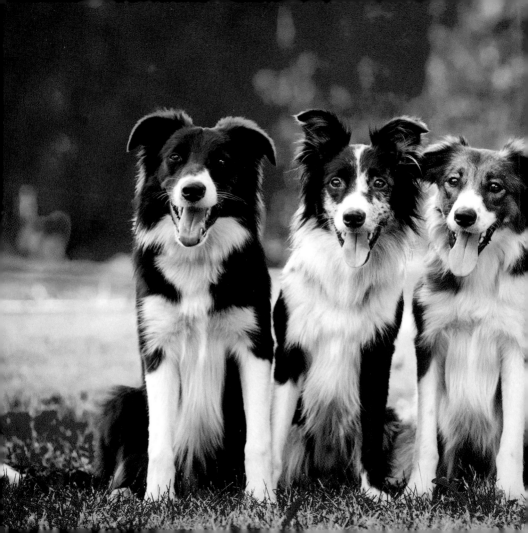

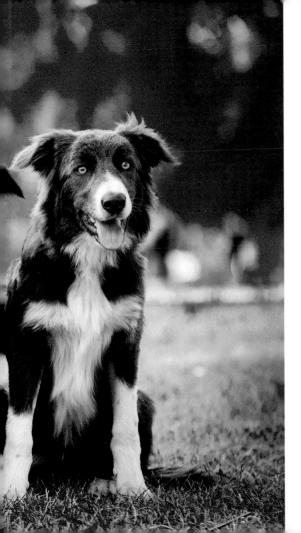

We have come to the decision that if you threw the ball, you can fetch it yourself.

135

Jack, I want you to kiss me like one of your French pups.

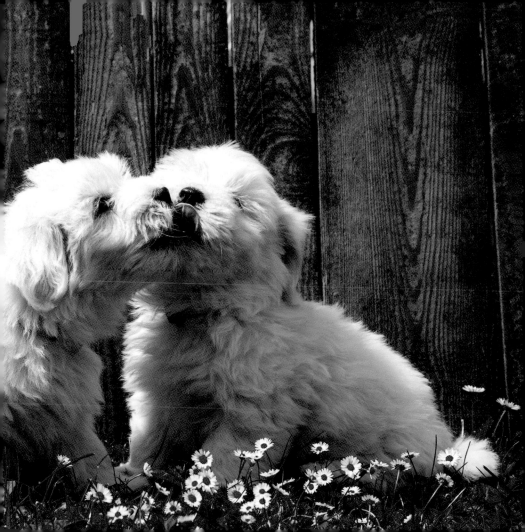

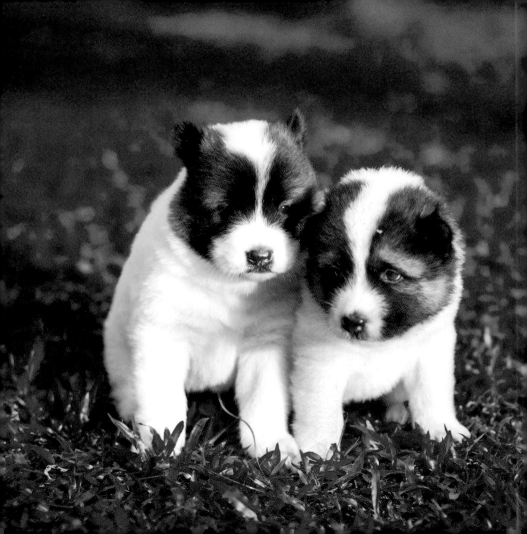

Well, the great outdoors is all well and good, but we could be curled up by a log fire, tucking into a juicy bone right now . . .

Under love's heavy burden do I sink!